HISS! POP! BOOM!

Celebrating Chinese New Year

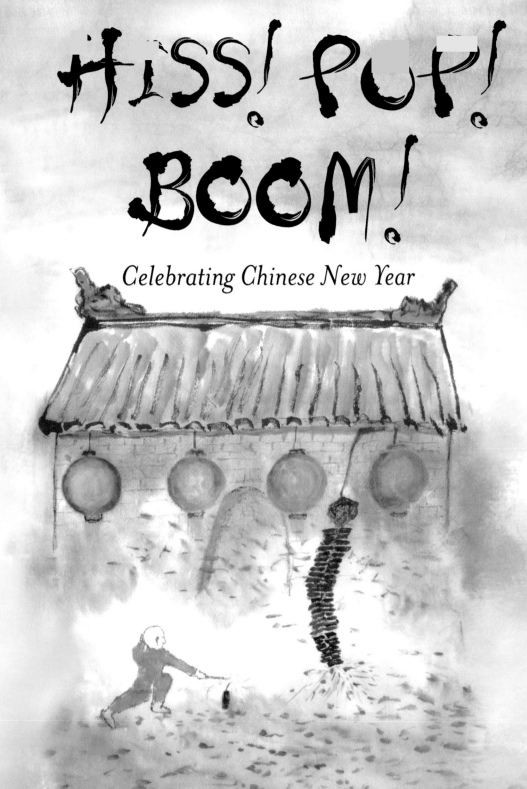

By Tricia Morrissey with Illustrations by Kong Lee

Chinese Brush Painting and Chinese Calligraphy

THINGSASIAN KIDS

Hiss! Pop! Boom! Celebrating Chinese New Year
By Tricia Morrissey with illustrations by Kong Lee
Cover and book design by Janet McKelpin

For information regarding permissions, write to:
ThingsAsian Press
3230 Scott Street
San Francisco, California 94123 USA
info@thingsasianpress.com
www.thingsasianpress.com

Printed in Singapore

ISBN 10: 0-9715940-7-4
ISBN 13: 978-0-9715940-7-4

"If heaven drops a date, open your mouth."

— Chinese Proverb

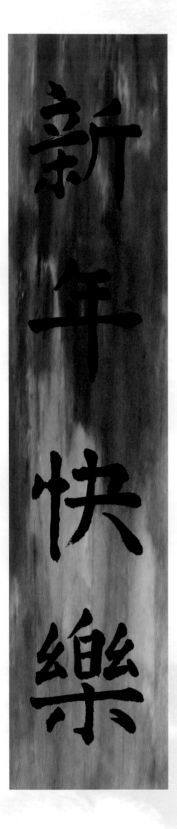

"Hiss!" and "Pop!" snap the firecrackers! "Boom!" says the drum to the Lion Dancer. Chinese New Year is here! Aunties and uncles have come from the city. Cousins visit from nearby towns. Everyone wants to be together for the celebration.

Long ago, when many families lived on farms, they called Chinese New Year the Spring Festival. With clearer skies and warmer winds came anticipation for what lay ahead. Seeing spring on the way, they would get ready to plant fresh food, hope for a strong, new harvest, and welcome visits from old friends. "Gung hey fat choy!" they would say to each other, "Congratulations and wealth!" or "Xin nian kuai le!", which means "New Year happiness!"

Now the fifteen-day New Year celebration bursts with traditions. Have you seen the Lion Dance or heard the sharp, snapping firecrackers? Have you been given a bright red envelope or a piece of sweet, sugary melon? With a new year, there are so many things to hope for. Maybe new babies will join the family; maybe old grudges will be forgotten. The new year is full of possibilities.

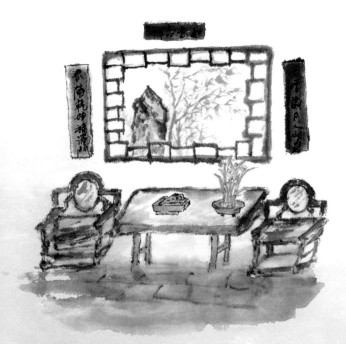

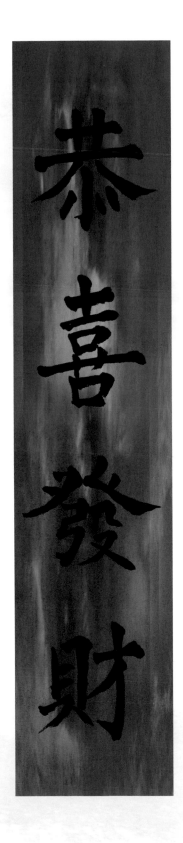

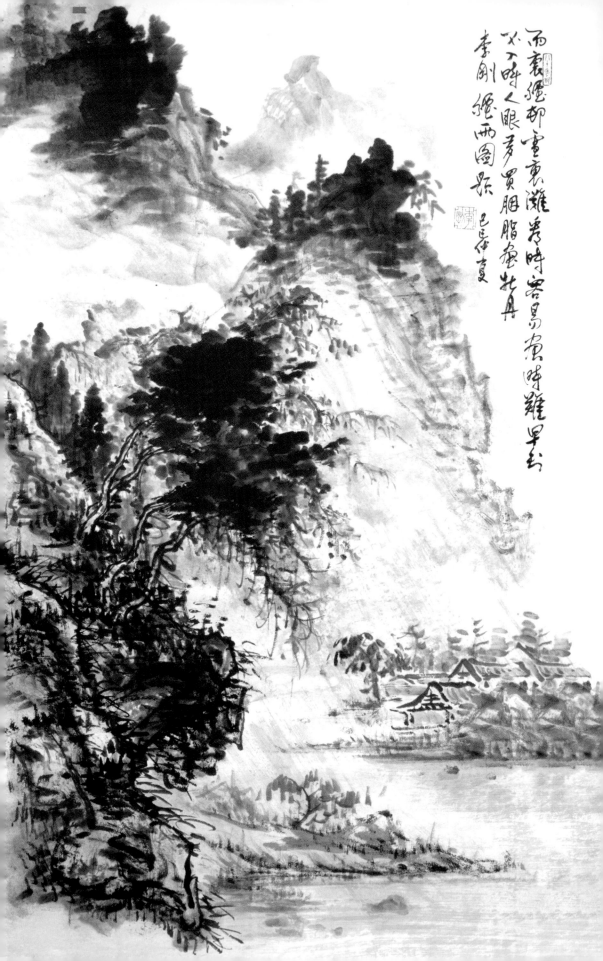

A New Year's Legend

One New Year's eve, local bandits played a trick on a nearby village. Using bamboo and scraps of cloth, the bandits disguised themselves as a strange and scary animal. Roaring and stomping, the wild beast made its way to town. The villagers were so frightened they ran to the forest and hid in the dark all night. With no one to stop them, the bandits ransacked the village and stole precious grain from the barns.

The next day, the tired villagers crept home to discover their belongings tossed about; overturned tables and broken bowls lay carelessly on the floor. It was the work of the strange animal. They called it the Nian ("Year") because it came on the eve of the new year.

Working together, the villagers devised a fiery plan to scare the menacing Nian away. When the creature appeared again, some villagers were disguised as ferocious lions. They leaped toward the strange beast, howling and banging pots and pans. Other villagers waved torches and set off shrieking, smoking firecrackers. The bandits cried out in terror and fled from the village.

The next year, and every year that followed, the villagers made lion costumes on New Year's eve, in case the fearsome Nian returned. Though it never has, families still spend the New Year together, sending off the hardships of the old year with blazing lanterns, firecrackers and a Lion Dance.

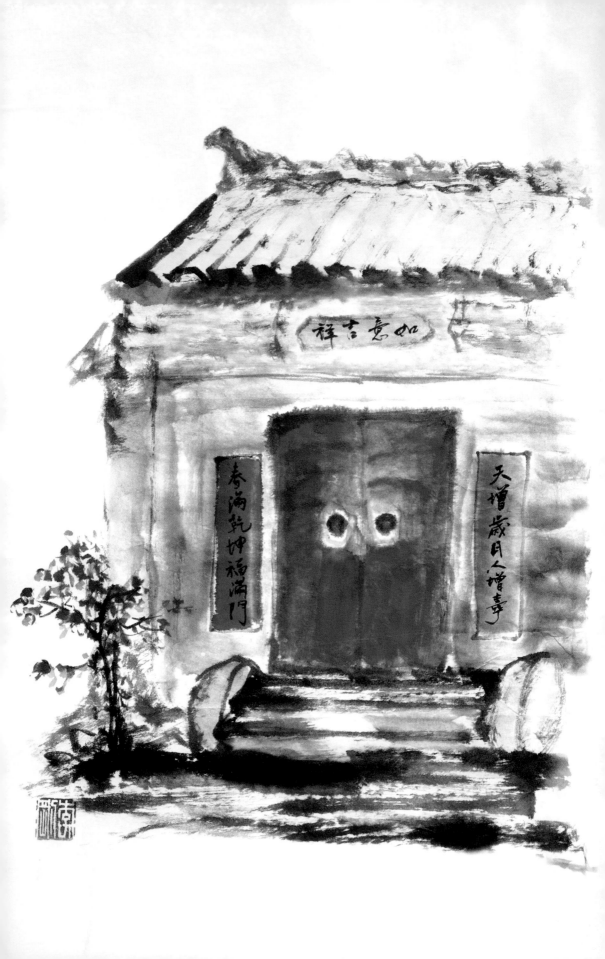

春節

NEW YEAR'S TRADITIONS

For a fresh start in the new year, families spend the last days of the old year sweeping floors, cutting hair, washing old clothes and buying new clothes. Red banners painted with hopeful poems decorate each side of the front door. When everything is new again, and the banners hang brightly, brooms, brushes and scissors are put away. Now the family is ready to celebrate.

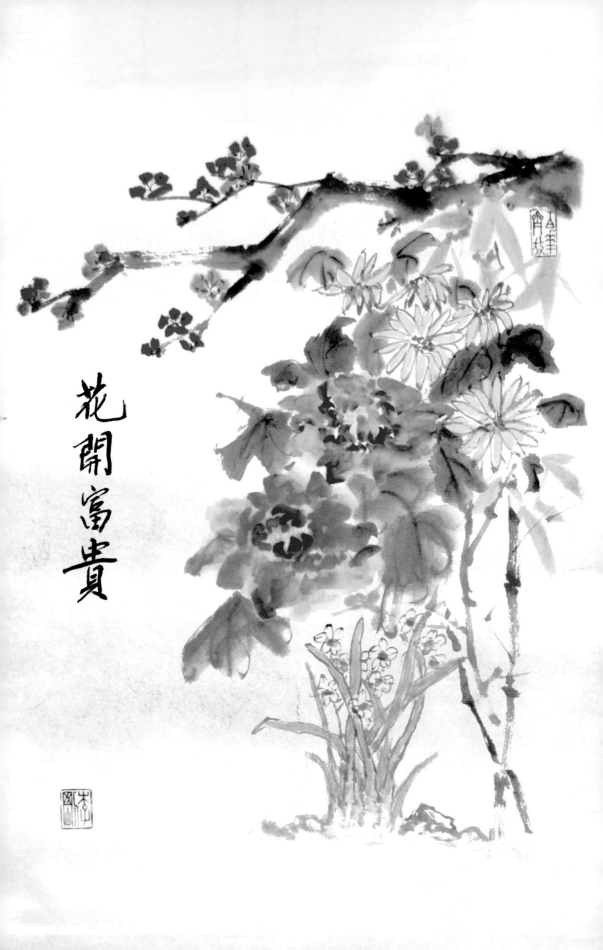

花開富貴

花

Flowers & Plants

To bring the sweet scent of spring inside, families visit the flower market on the day before the new year. Pretty branches of plum blossoms, which symbolize perseverance, are arranged with strong, flexible bamboo stalks. Add a green pine sprig to show constancy, or a golden kumquat, which represents wealth. You might also see pussy willows, azaleas, water narcissus, or peonies, China's national flower.

Eating Together

New Year's feasting begins on New Year's eve. In northern China, families gather at kitchen tables to stuff and steam dumplings. Families in the south like to eat "nian gao", a sweet, sticky rice cake.

The next day, platters of delicious, steamy food blanket the table. A fish is served whole to show the family has been given more than enough. Steamed chickens, with their heads, tails and feet still attached, symbolize togetherness. And long noodles are eaten to show hope for a long, long life.

魚

年年有餘

舞
獅

LION DANCE

The shimmering, frolicking
Lion Dance banishes last year's
troubles and welcomes the new
year's promises. As one person
hoists the lion's head, and
another moves with the body
and tail, the lion begins to dance.
Musicians beat a thunderous
rhythm with a drum, a gong
and cymbals, tempting the lively
lion to prance and jump.

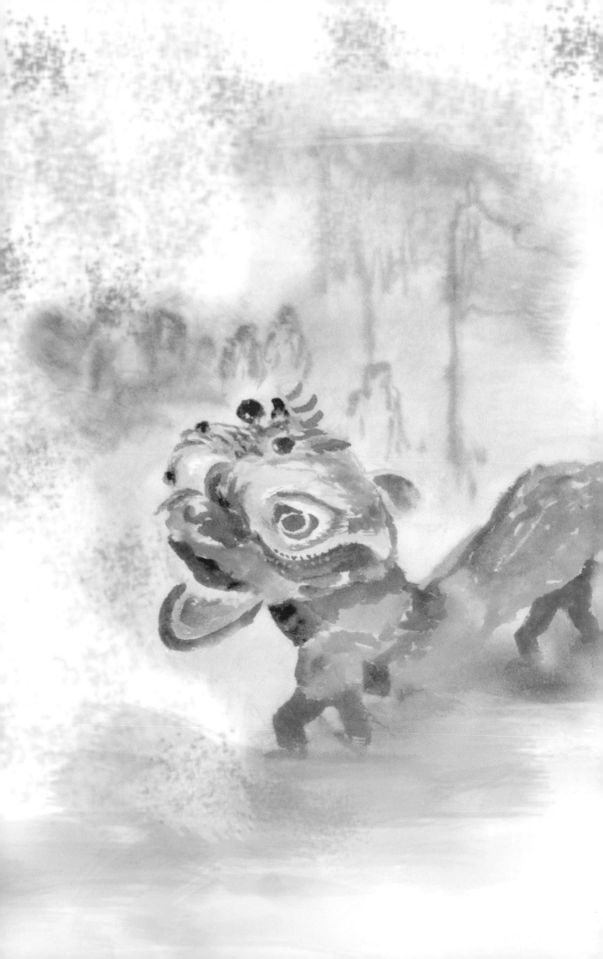

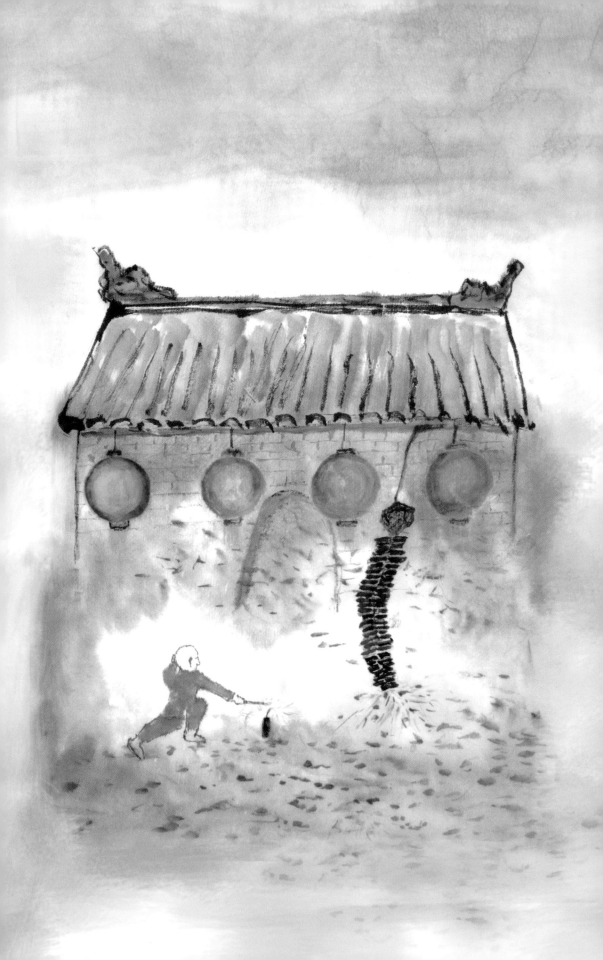

炮
仗

FIRECRACKERS

To scare away the terrible Nian, the daring villagers lit hissing, popping firecrackers. Now the first hours of every new year are filled with the sounds of Hiss! Pop! Boom! After the last firecracker explodes, when everything is quiet, the wrappers lie like a red carpet on shop floors and sidewalks.

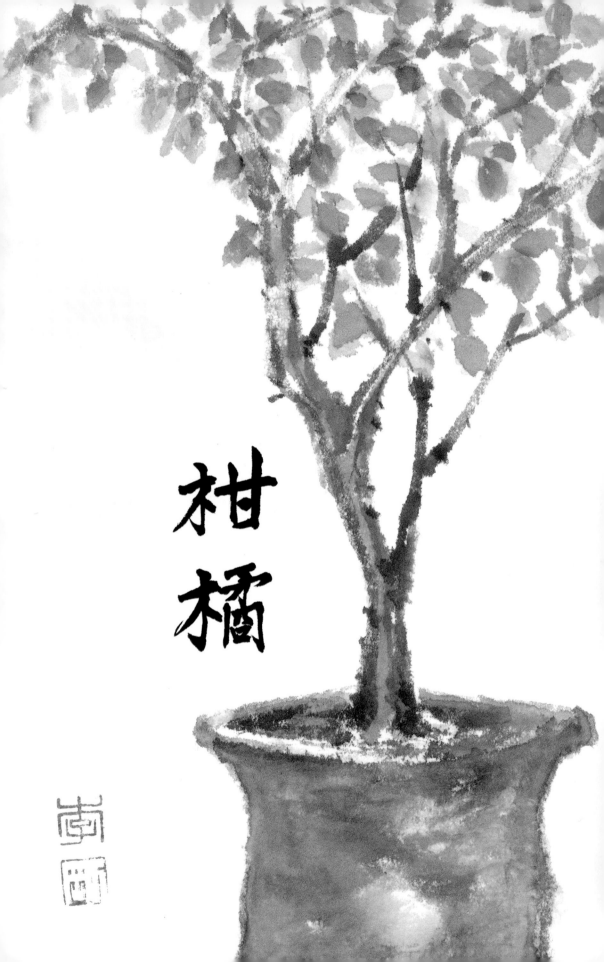

柑
橘

Fruit

Families and friends carry bright oranges, leafy tangerines and golden pomelos when they stop to visit during Chinese New Year. Oranges symbolize wealth because the Cantonese words for "orange" and "wealth" sound alike. The words for "tangerine" and "luck" also sound alike, and the word for "pomelo" sounds like the word for "to have". Tangerines given with the leaves still on show that your family ties are strong.

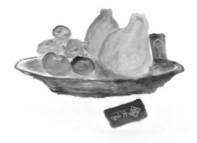

全盒

TRAY OF HAPPINESS

A tray full of happiness sits by the door, ready to share with visitors. Sweet dried fruits like candied melon, lychee nuts, kumquats, longan and coconut sit beside salty, dyed red melon seeds, lotus seeds and peanuts. Each food represents something to hope for in the new year: good health, a strong family, prosperity, being together, happiness, many babies, good children and a long life.

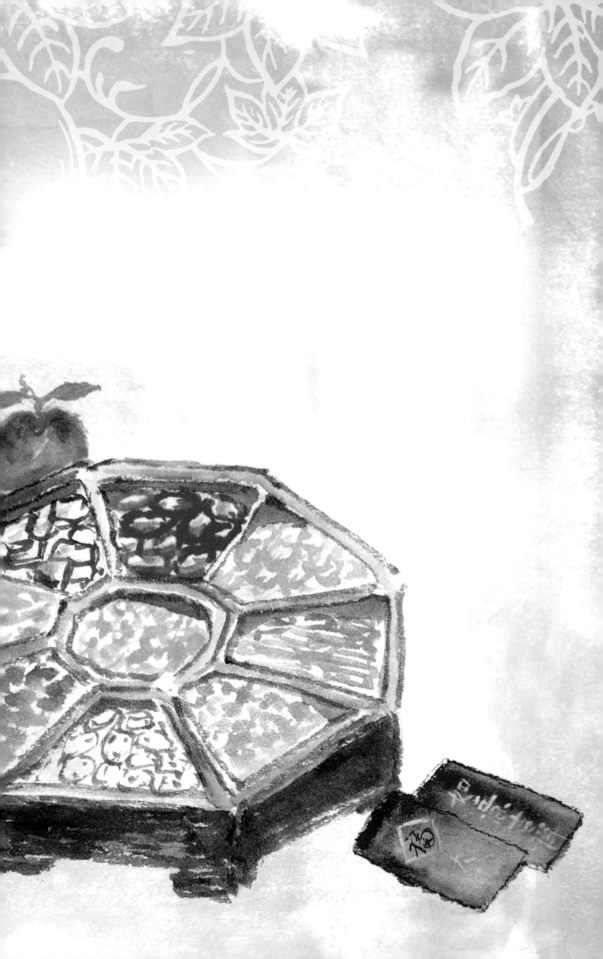

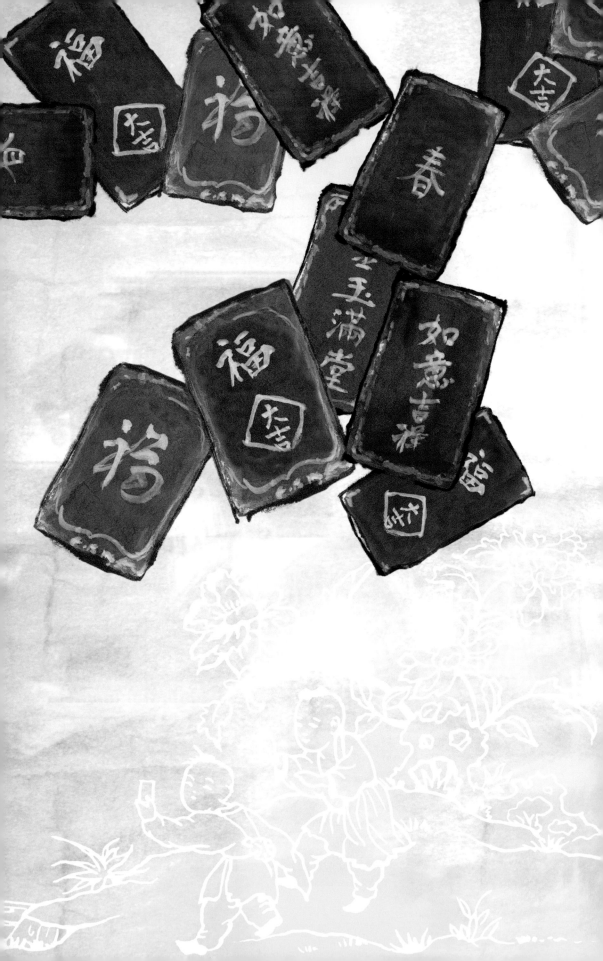

利
是

Red Envelopes

Children's pockets bulge with a windfall of shiny, red envelopes. Each envelope is a gift; the glossy, red paper and golden designs symbolize hope for happiness in the new year. Open them later to find coins—or maybe even crisp paper money—to spend as you like on new toys and sweet candy.

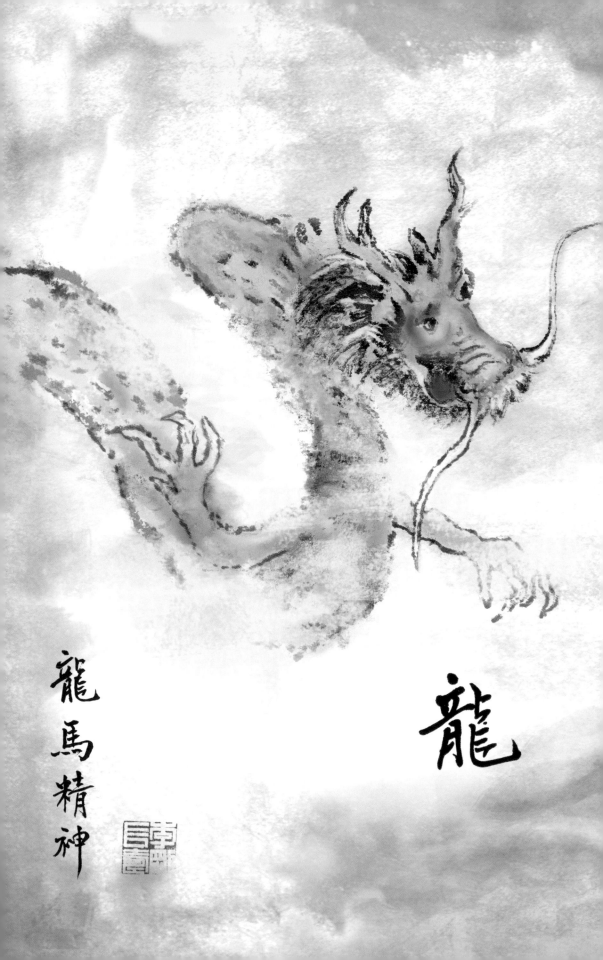

龍馬精神

龍

Parades

On the Champs Elysées in Paris, on Singapore's Orchard Road, and on Canal Street in New York City, thousands of spectators jam the sidewalks. They won't be disappointed. Soon, a parade full of dancing lions, fierce dragons, springing acrobats, stilt walkers and noisy marching bands will wind through their Chinatowns.

San Francisco's exuberant parade boasts a Golden Dragon that is over 200 feet long. One hundred men and women weave the great Dragon through the city streets. The parade ends when the mighty Dragon dances to the crackle of 600,000 firecrackers.

燈籠

Lantern Festival

Chinese New Year ends with the Lantern Festival, when bright paper lanterns help the full moon light up the sky. Made of bamboo and colorful, delicate paper, some lanterns are decorated with funny riddles. While you ponder them, watch for the lion and dragon dancers and eat some "yuan xiao", the sticky, round dumplings that bring the Lantern Festival, and the whole New Year celebration, to a sweet close.

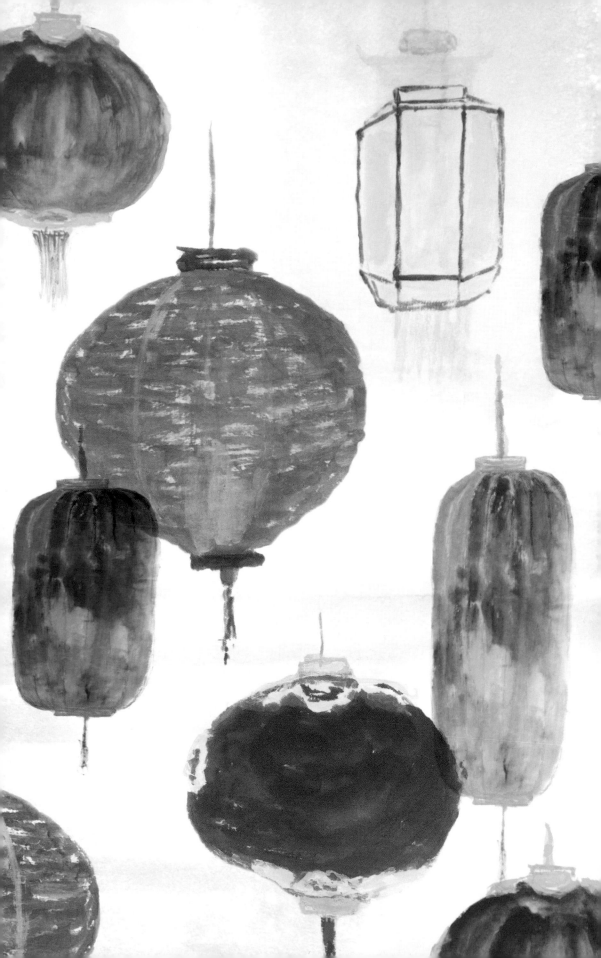

Chinese Calligraphy

Chinese calligraphy is the art of writing Chinese characters with a brush. Calligraphers have to follow strict rules. Each character requires a certain number of brush strokes written in a specific order. Calligraphers have followed the same rules for thousands of years. Still, just as with handwriting and drawing, every person's calligraphy looks a little different.

Chinese calligraphers use four tools, which they call The Four Treasures of the Study. The first tool, the brush, is made by sliding animal hair into a bamboo or wooden tube. Stiff wolf hair makes a brush with a hard, precise tip. Soft, white goat hair and black rabbit hair hold more ink and make the calligrapher's brush strokes look dense and heavy.

The second tool, the ink stick, is made by burning pine sap or oil and mixing the soot with glue. This sticky mixture is pressed into molds and allowed to dry, becoming hard sticks of dry ink.

Calligraphers make liquid ink by rubbing the ink sticks, clean water and a little salt against hard, smooth ink stones. The best ink stones are carved from river rocks and are handed down from generation to generation.

Before paper was invented, calligraphers wrote on strips of dried bamboo or silk. Today, calligraphers use rice paper—thin, delicate paper made, not from rice, but from material inside the trunk of a rice paper tree.

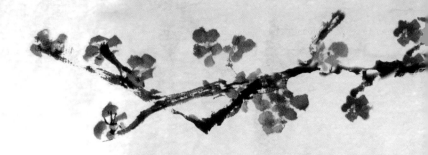

CHINESE BRUSH PAINTING

Chinese brush paintings decorate each page of this book. If you look closely, you will see the painter's strokes. This style of painting has been practiced in China for over 6,000 years.

Traditional Chinese artists paint human figures, landscapes, birds and flowers. Painters use their brushes and paints to show how the bird's feathers feel silky, how the waterfall pours down the mountain and sprays the trees, and how the court lady's steps are graceful and elegant.

An artist will sometimes complement his or her painting by writing a poem next to the picture. Written in calligraphy, the poem may explain the

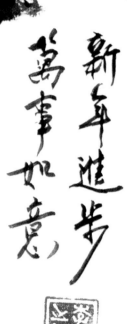

painting's theme, share the artist's reason for painting the picture, or reveal the name of the person who will receive the painting.

After the painting and the calligraphy are finished, the artist will sign the painting by adding a seal. Seals are stamps made by carving Chinese characters into stone or wood. The characters on the seal may be the artist's name, a traditional saying, or the painting's theme. The artist dips the seal in scarlet red paint and presses it to the paper. Adding a red seal to a black and white painting is called "adding the eye to the dragon."

Tricia Morrissey was born in Nairobi, Kenya and spent her childhood in Africa, Greece, Iowa, Georgia and Kansas. She now lives in San Francisco with her friends Galen, Amy and Jordan. The red envelope page is her favorite painting in this book. Other books by Ms. Morrissey include *My Mom is a Dragon and My Dad is a Boar*.

Kong Lee was born in Guangzhou, China, but grew up in Hong Kong. His love for Chinese calligraphy, brush painting, and photography began at a very young age. Mr. Lee's work, which is inspired by his love of travel, has been exhibited throughout China and California. Mr. Lee lives in California with his family.

Other ThingsAsian Kids books: *My Mom is a Dragon and My Dad is a Boar*, a whimsical introduction to Chinese paper cut art and the lunar calendar animals.

For more information about Asia and Asia-related activities for kids, visit
Kids.ThingsAsian.com

Printed and bound by Tien Wah Press, Singapore
Book design by Janet McKelpin
Book production by Paul Tomanpos, Jr.